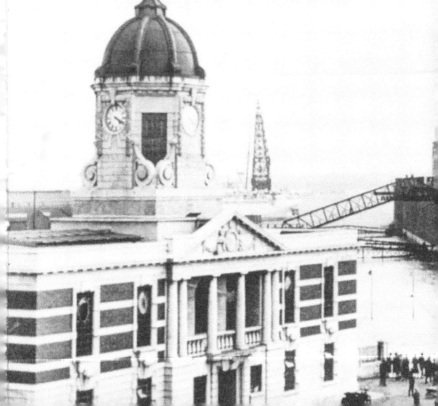

SOUTHAMPTON

HISTORY TOUR

First published 2010
This edition published 2014

Amberley Publishing
The Hill, Stroud,
Gloucestershire, GL5 4EP
www.amberley-books.com

Copyright © Jeffery Pain, 2014

The right of Jeffery Pain to be identified
as the Author of this work has been
asserted in accordance with the
Copyrights, Designs and Patents Act
1988.

ISBN 978 1 4456 4151 5 (print)
ISBN 978 1 4456 4165 2 (ebook)

British Library Cataloguing in
Publication Data.
A catalogue record for this book is
available from the British Library.

Typesetting by Amberley Publishing.
Printed in Great Britain.

Map on pages 4 & 5 courtesy of
OS Streetview.

INTRODUCTION

Southampton has a long history with some evidence of Stone and Bronze Age settlements. However, in recorded time there was a Roman presence protected by a moat on the River Itchen called *Clausentum*. Later on, in Saxon times, a large trading centre named Hamwich was established on the west bank around the Northam area, and this in turn was replaced by an area on slightly higher ground on the River Test side by the tenth century, which became fully stone walled by the fourteenth century, being the basis of the modern town.

From the Norman to Tudor times, it was a thriving port with imports including wine and exports of wool. Later, after some two centuries of decline, its fortunes were revived with arrival of the railway from London in 1840 and the opening the docks in 1842. The docks have developed over the subsequent years with an emphasis in the twentieth century on passengers, which is maintained today by the presence of some of the largest cruise liners in the world.

An unlikely phase occurred in the late eighteenth century when, for a while, the town became a spa renowned for its baths with health giving properties (allegedly). Around this time Jane Austen spent five years in the town, but she was not inspired to pen any novels during this period (presumably she was too busy enjoying the attractions of the spa).

So with the coming of the railway and the docks the town developed into the city of today, though with many trials and tribulations in times of war, financial problems and over labour disputes.

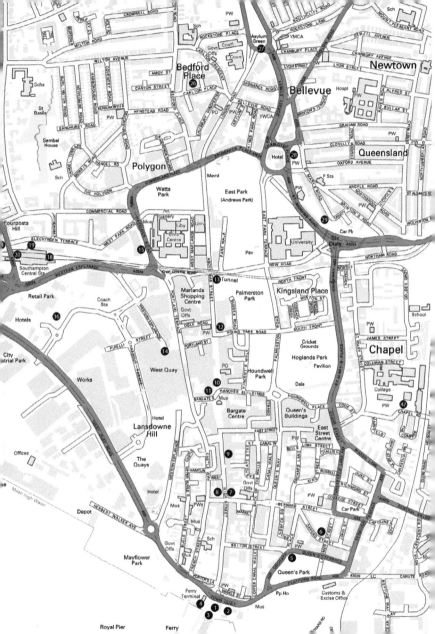

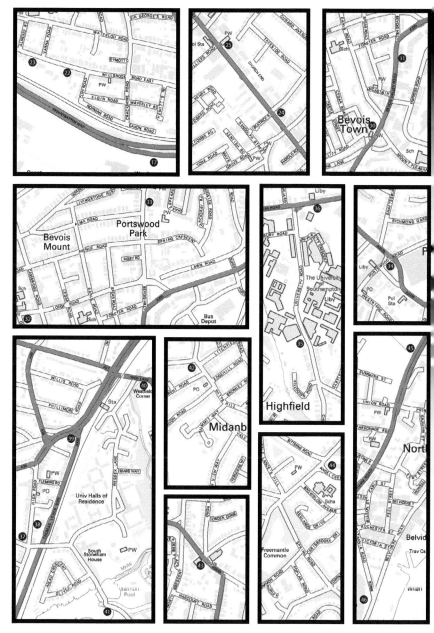

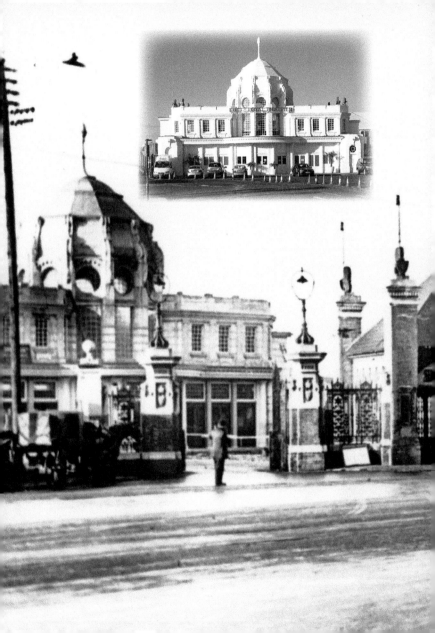

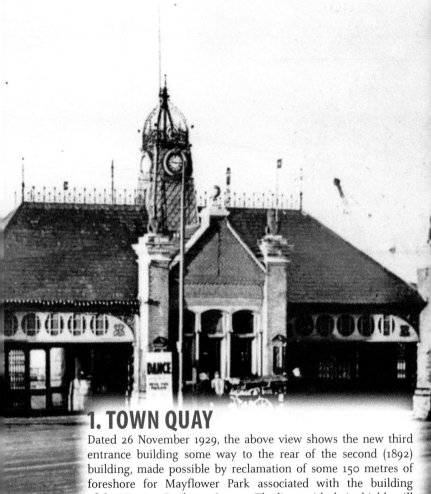

1. TOWN QUAY

Dated 26 November 1929, the above view shows the new third entrance building some way to the rear of the second (1892) building, made possible by reclamation of some 150 metres of foreshore for Mayflower Park associated with the building of the Western Docks 1928–1933. The lions with their shields will be transferred to the new building, though without the flags and poles. The gateposts are also still in evidence but a little further apart and obviously without gates.

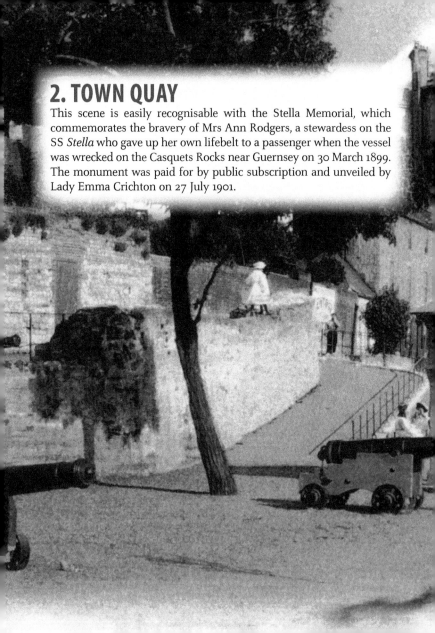

2. TOWN QUAY

This scene is easily recognisable with the Stella Memorial, which commemorates the bravery of Mrs Ann Rodgers, a stewardess on the SS *Stella* who gave up her own lifebelt to a passenger when the vessel was wrecked on the Casquets Rocks near Guernsey on 30 March 1899. The monument was paid for by public subscription and unveiled by Lady Emma Crichton on 27 July 1901.

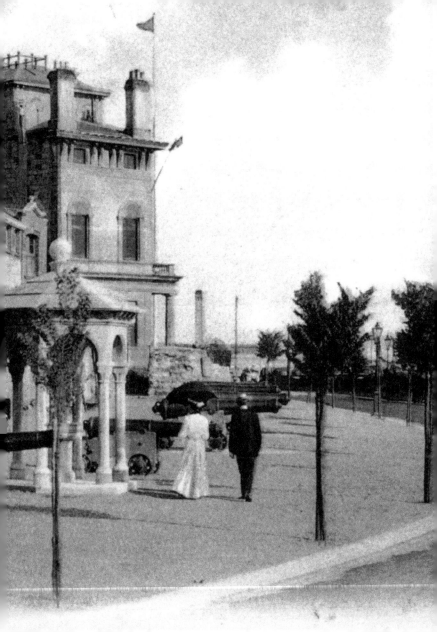

3. TOWN QUAY

Owing to new buildings, the angle is slightly altered. Looking at the original, the first pier entrance (single story) is on the extreme left, followed by the Yacht Club, and just visible is the Wool House (destroyed during the war), the Royal Pier Hotel, and two warehouse blocks. Finally, you can see another warehouse, which is now a restaurant and flats; an attractive building, which at one time served as the Custom House; and shipping offices, which is currently a Tapas restaurant.

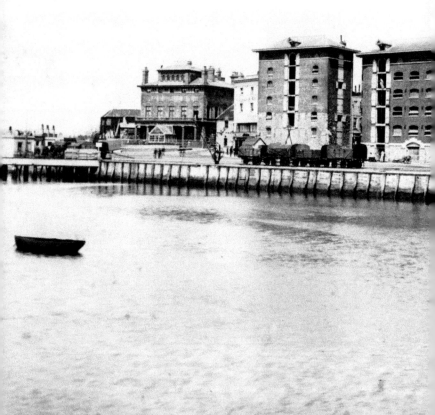

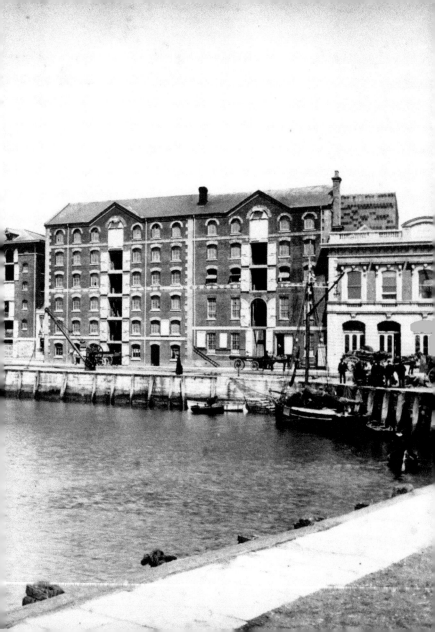

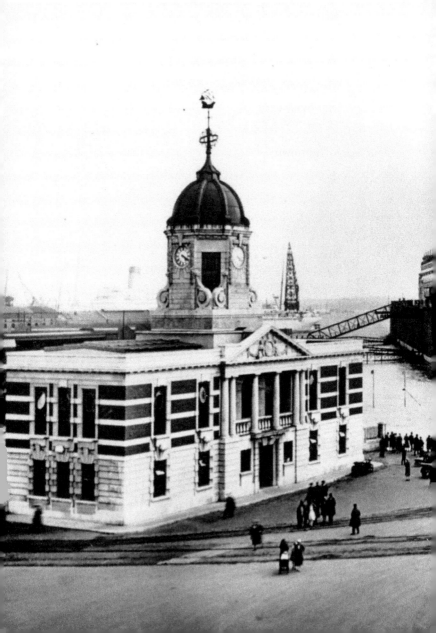

4. TOWN QUAY

On the left are the newly built Harbour Board offices, and centre stage is the floating dry dock, with the *Berengaria* out of the water. To the right is the town quay. Also note the area available to the public who could view the world's largest vessels high and dry. The dry dock was sold to the navy and went to Portsmouth in 1940. The Harbour Board is long gone and the building is now a casino. The town quay has been converted into restaurants, offices and flats, and is now used by some ferry services.

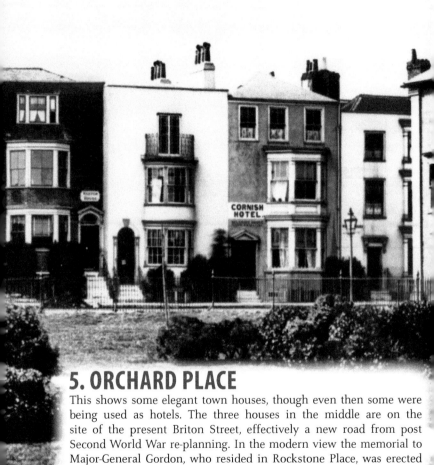

5. ORCHARD PLACE

This shows some elegant town houses, though even then some were being used as hotels. The three houses in the middle are on the site of the present Briton Street, effectively a new road from post Second World War re-planning. In the modern view the memorial to Major-General Gordon, who resided in Rockstone Place, was erected in 1885. Trees cover most of the background, but Briton Street is just visible between the trees.

6. OXFORD STREET

Once again a shot that captures the time with what appears to be a young lad hitching a ride on the tram fender, unfortunately for tram enthusiasts obscuring the number. The undistinguished buildings on the right became a pub and an office block with a Marine Outfitters on the ground floor; however, this shop, amongst others in the area, have now all become restaurants.

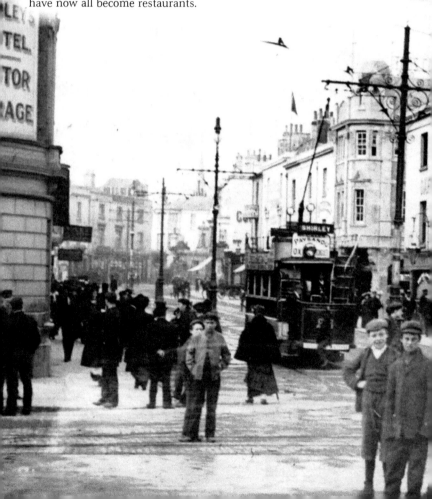

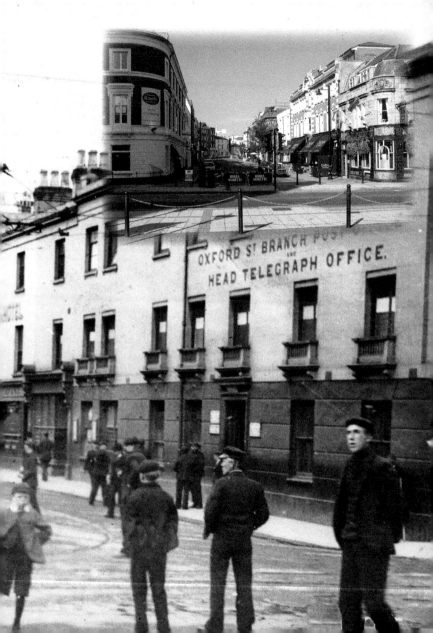

7. BERNARD STREET

Looking east from Holy Rood church along Bridge Street, now Bernard Street. Apart from Holy Rood church on the left nothing in view remains mainly through Second World War bomb damage. I do think that some of the old buildings were more attractive. Note the decoration work around the junction of the support poles and spans for the overhead tram wires, this design was unique to Southampton and is useful in identifying otherwise mystery pictures.

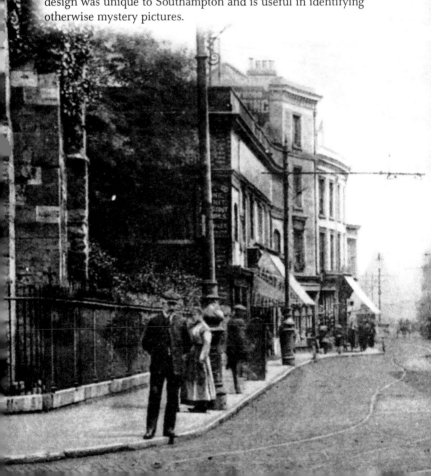

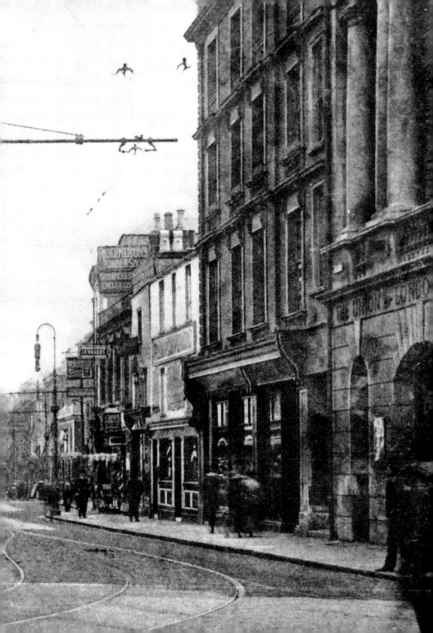

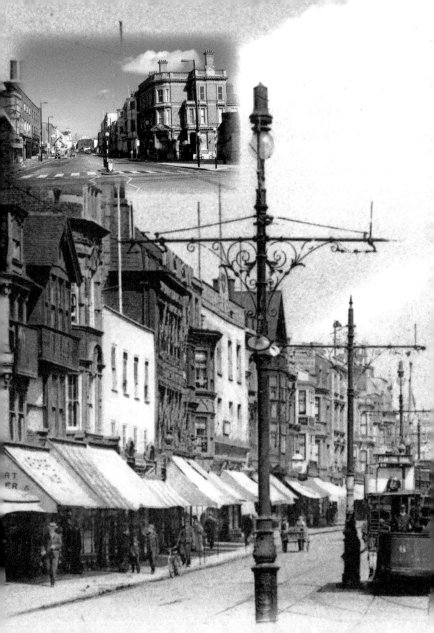

8. HIGH STREET

Looking north from Holy Rood church, note again tracery on the support poles. The Dolphin Hotel and the building this side of it remain, but otherwise the majority were bombed or redeveloped. Even St Lawrence's church was redundant and demolished in 1927. On the left only the Midland Bank, which is visible in the distance, remains.

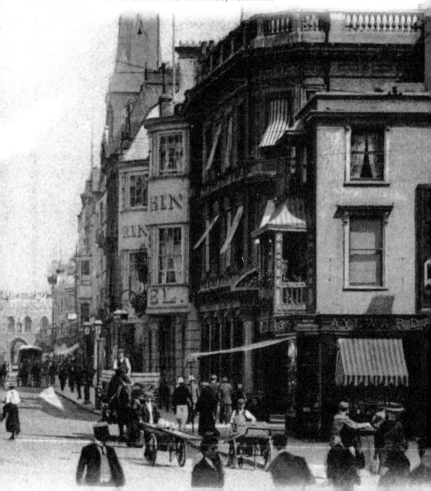

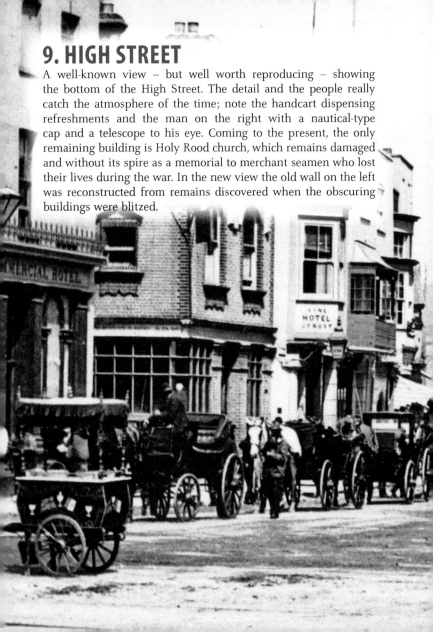

9. HIGH STREET

A well-known view – but well worth reproducing – showing the bottom of the High Street. The detail and the people really catch the atmosphere of the time; note the handcart dispensing refreshments and the man on the right with a nautical-type cap and a telescope to his eye. Coming to the present, the only remaining building is Holy Rood church, which remains damaged and without its spire as a memorial to merchant seamen who lost their lives during the war. In the new view the old wall on the left was reconstructed from remains discovered when the obscuring buildings were blitzed.

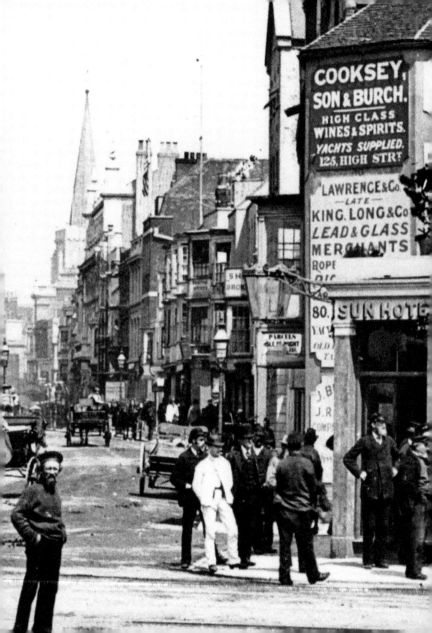

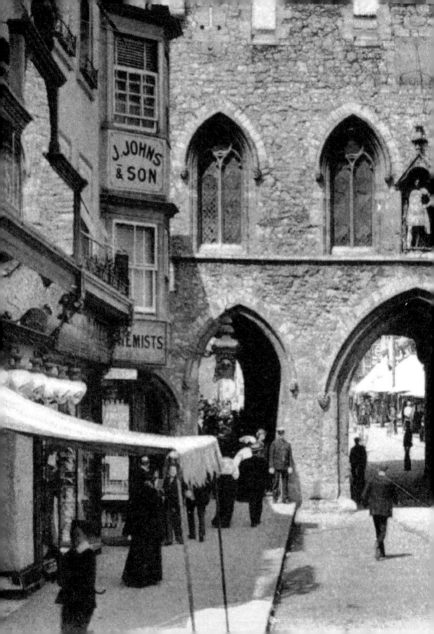

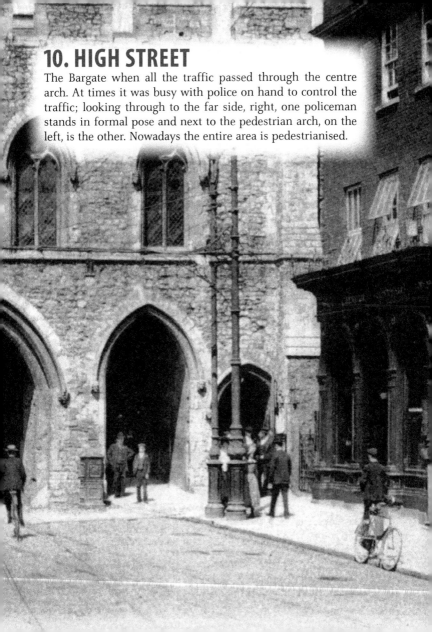

10. HIGH STREET

The Bargate when all the traffic passed through the centre arch. At times it was busy with police on hand to control the traffic; looking through to the far side, right, one policeman stands in formal pose and next to the pedestrian arch, on the left, is the other. Nowadays the entire area is pedestrianised.

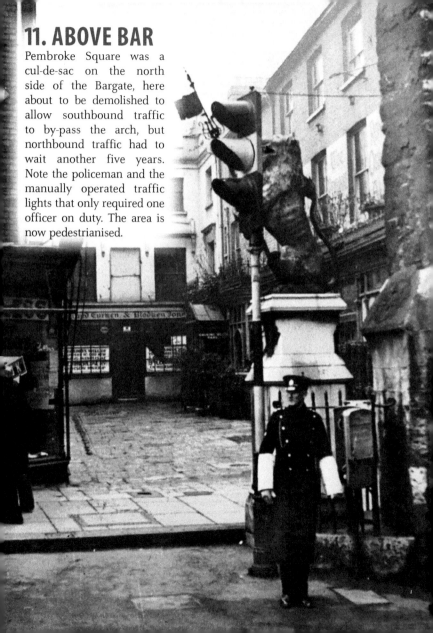

11. ABOVE BAR

Pembroke Square was a cul-de-sac on the north side of the Bargate, here about to be demolished to allow southbound traffic to by-pass the arch, but northbound traffic had to wait another five years. Note the policeman and the manually operated traffic lights that only required one officer on duty. The area is now pedestrianised.

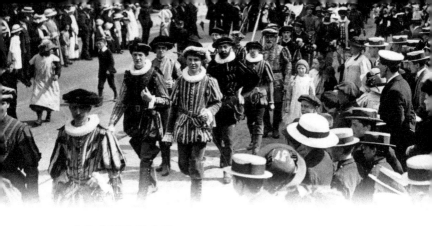

12. ABOVE BAR

This picture shows the Tudor Pageant of June 1914 passing through Above Bar, and on the left is Pound Tree Road — the Royal Hotel impressively centre of the picture. Above the Bargate are the spires of St Lawrence and Holy Rood. Looking at the modern picture, only the second building on the right and the Bargate remain. The pageant was to raise money to help pay for the spire of St Mary's church, which since completion of the main church in 1884 had remained without this feature.

13. ABOVE BAR

New Road and the clock tower. This was a drinking fountain donated for 'both man and beast' by Mrs Henrietta Bellenden Sayers in 1889. By 1935, it was considered a traffic hazard and reinstalled on the Triangle at Bitterne Park. The square-topped covered tram will not be able to go through the Bargate but will turn left for Northam and pass behind the tower.

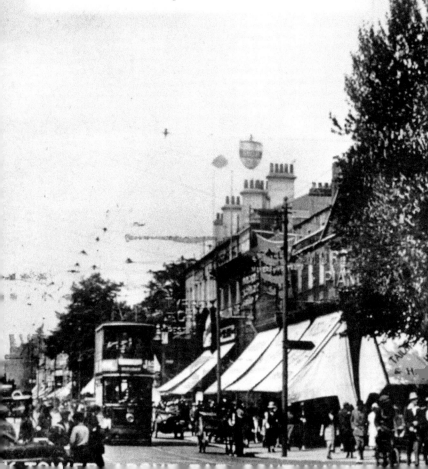

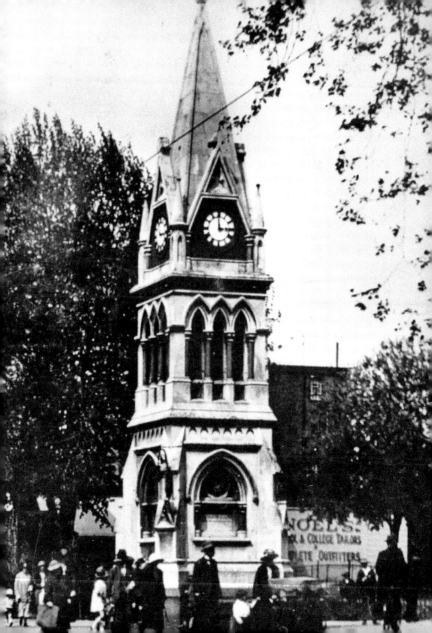

NOEL'S.
...OL & COLLEGE TAILORS
...LETE OUTFITTERS

14. WESTERN ESPLANADE

A lovely view at high tide with the water lapping at the town walls. In the middle distance can be seen the baths, with area behind about to welcome the electricity generating station, at this stage generating direct current only – alternating would come later, and the foreshore would disappear under Pirelli's cable factory. Now the trees have gone, giving a view of the walls, and so has everything else – in order to become the West Quay shopping centre.

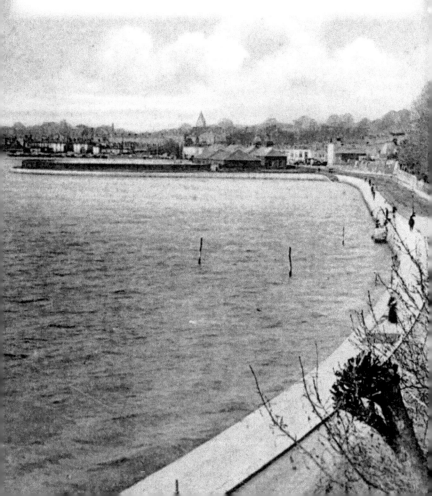

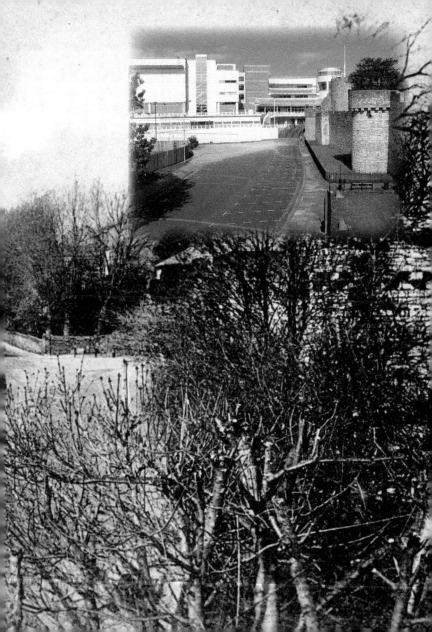

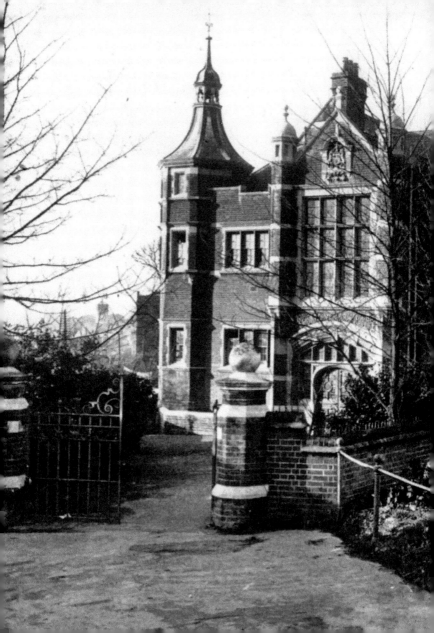

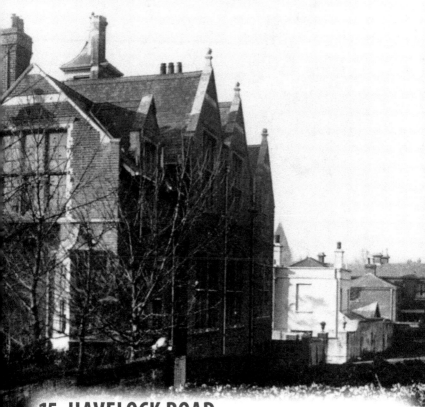

15. HAVELOCK ROAD

King Edward VI School obviously has a long history being founded in 1564 with premises in Winkle Street, then Bugle Street (1696–1896), and next were these buildings (1896–1938) and finally to new buildings in Hill Lane. When they moved just before the Second World War the buildings remained to become, with the addition of temporary huts at the rear, the local NAAFI Club for the duration of the war and a while afterwards. Demolition eventually followed and the site remained vacant until the BBC buildings were erected.

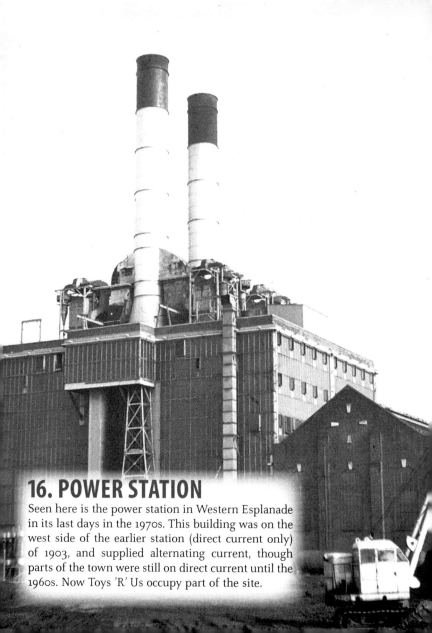

16. POWER STATION

Seen here is the power station in Western Esplanade in its last days in the 1970s. This building was on the west side of the earlier station (direct current only) of 1903, and supplied alternating current, though parts of the town were still on direct current until the 1960s. Now Toys 'R' Us occupy part of the site.

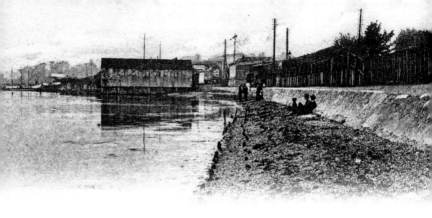

17. MOUNTBATTEN WAY

Pictured is the beach at Millbrook with railway and station. Centre is a clutch of sites, including tidal baths, yacht and boat builder, and the ferry to Marchwood. Luckily it is possible to replicate the position from the new dual carriageway, which accesses the town centre on the reclaimed mudflats between the docks and the railway line. Note the area on the left, once a car parts factory but, like so much of the docks hinterland, now used as a car park or for container storage.

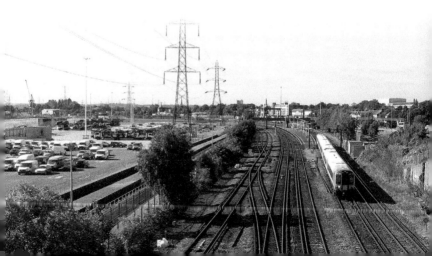

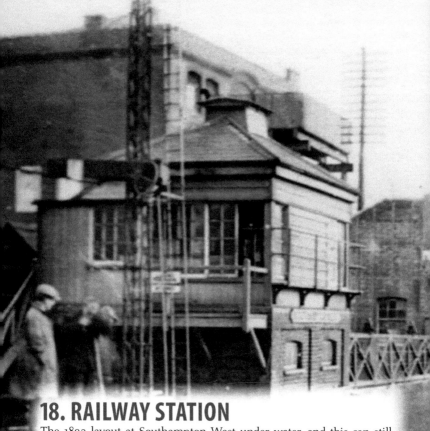

18. RAILWAY STATION

The 1892 layout at Southampton West under water, and this can still happen even now with the wrong weather conditions. Note the signal box with the level crossing gates — in use until the bridge over the western end of the station was opened in 1934/35. At the same time the station was enlarged to become Southampton Central. The footbridge is not part of the station but was for pedestrians to cross when the level crossing gates were shut. Visible under the bridge are remains of the original 'Blechynden' station.

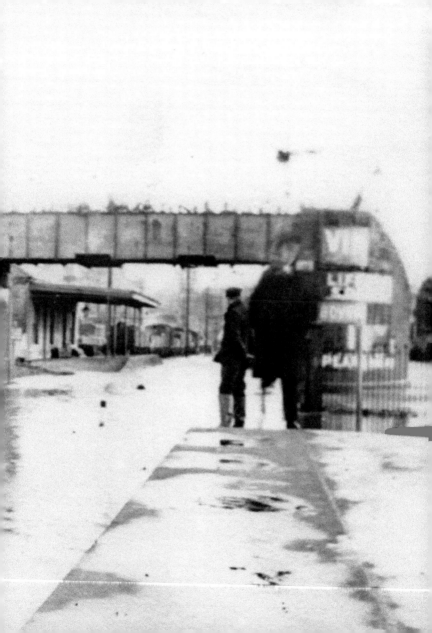

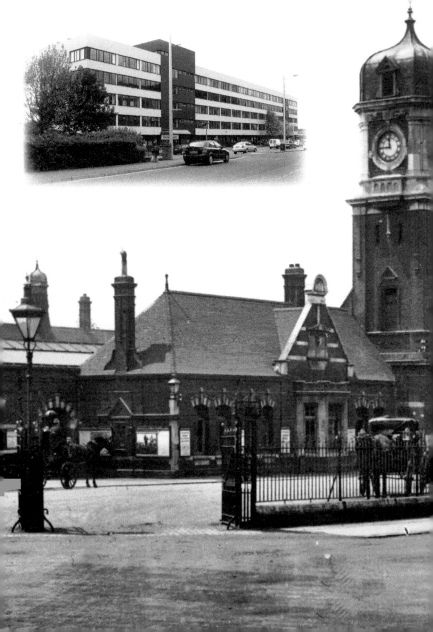

19. BROOK ROAD

The grand north (Up) side forecourt and entrance of the 1892 station without a car in sight. Though bomb damaged during the Second World War, the main part, including the clock tower, survived until modernised in association with the electrification of services in 1967. The current entrance is just visible on the right with double white arrows on a red background.

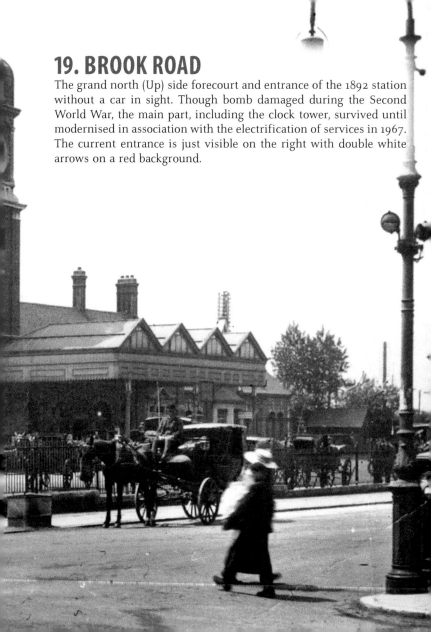

20. WESTERN ESPLANADE

Taken from the footbridge shown earlier, a royal train is about to pass through the station on its way to the Western Docks where the Queen with some of her family will board the royal yatch *Britannia* for their annual holiday in Scotland. Note changes to the buildings and a strangely empty car park (must be the weekend).

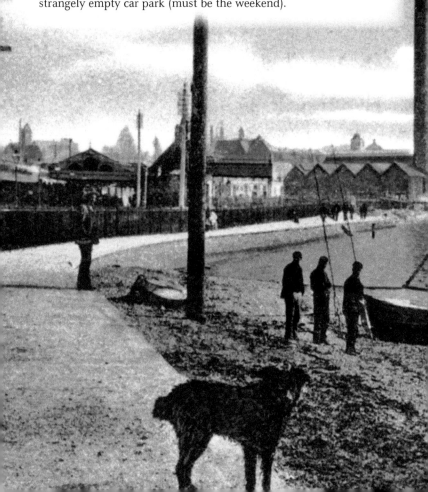

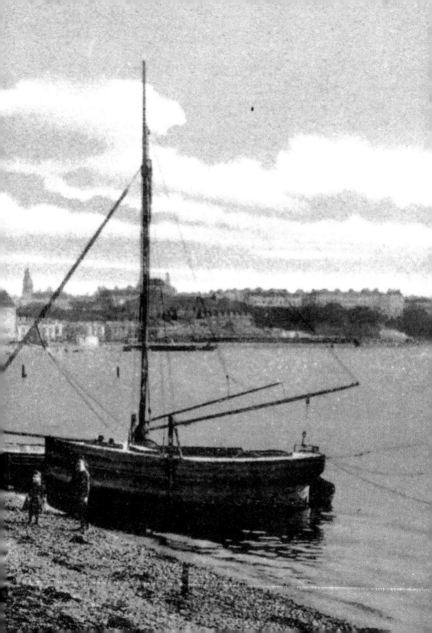

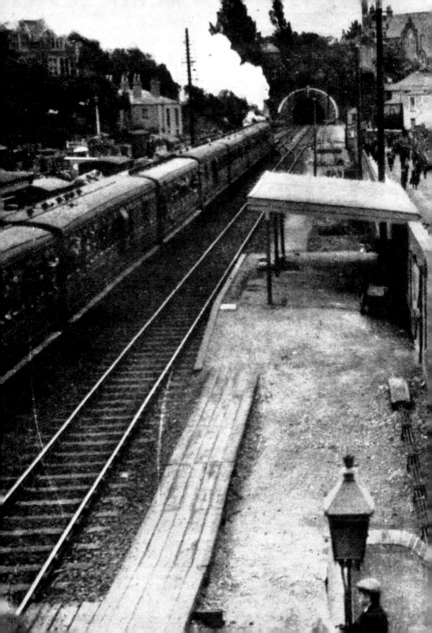

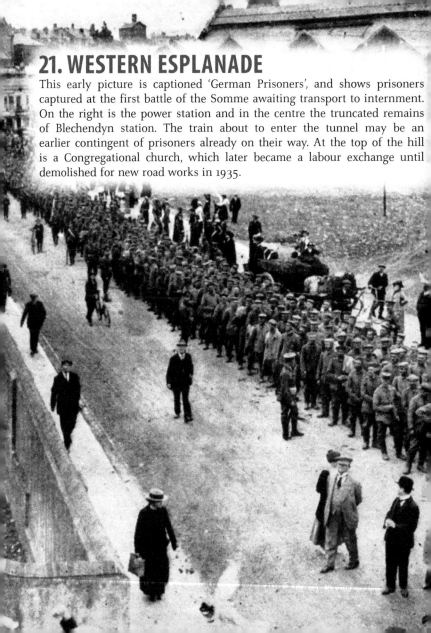

21. WESTERN ESPLANADE

This early picture is captioned 'German Prisoners', and shows prisoners captured at the first battle of the Somme awaiting transport to internment. On the right is the power station and in the centre the truncated remains of Blechendyn station. The train about to enter the tunnel may be an earlier contingent of prisoners already on their way. At the top of the hill is a Congregational church, which later became a labour exchange until demolished for new road works in 1935.

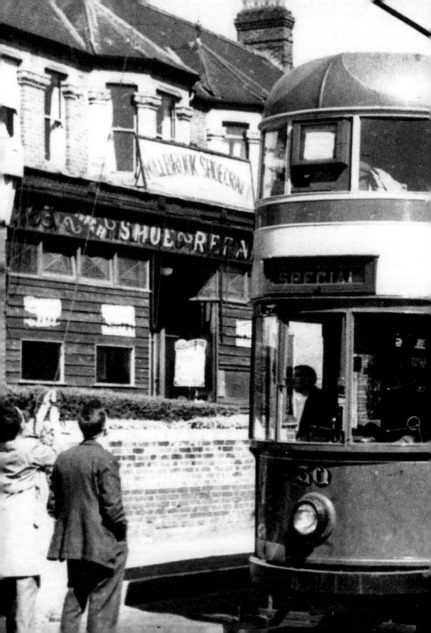

22. MILLBROOK ROAD

This view at Millbrook Tram terminus was taken on a special trip when the 'Light Railway Transport League' hired No. 50, the first tram repainted after the war for a tour of the system. This branch had closed to normal traffic in 1935 but was used for workman's cars until *c.* 1946. Note the shop front with partially boarded windows. This was quite common after blast damage as during the war replacement supplies of glass were problematic. The buildings remain, though the shop front has been bricked up.

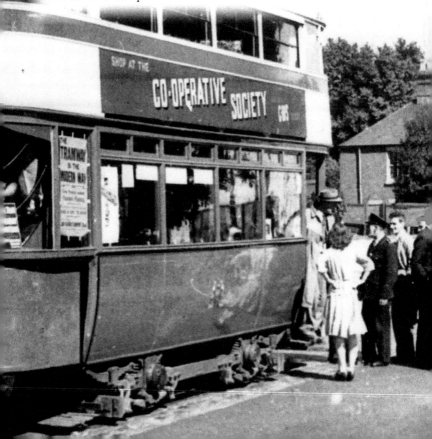

23. MILLBROOK ROAD

This view at the time was outside the borough boundary, which was Tanners Brook, this being marked by the bridge walls in the middle distance. Nowadays, with the six-lane dual carriageway, it is difficult to spot, but in the centre of the picture to the right of the trees is a white platform bed truck and a roadworks sign, and the brick wall alongside marks Tanners Brook. From this point it is piped under industrial units and the docks until it reaches the river.

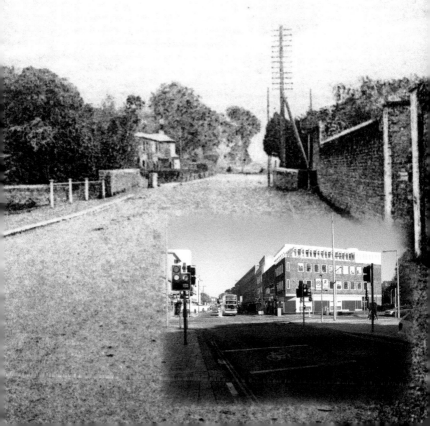

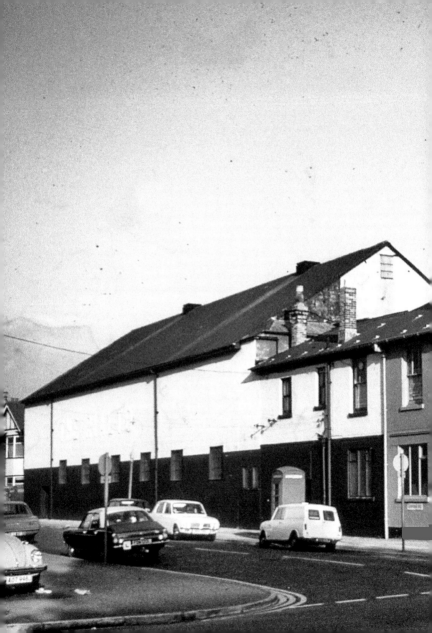

24. SHIRLEY HIGH STREET

The Rialto was a purpose-built cinema with seating for 928 people at the rear of buildings facing the main road, which opened on 9 January 1922. No. 325 Shirley Road was the entrance foyer leading to the auditorium. It was independently owned until bought by the Odeon circuit in 1937, closure coming in November 1960. The entrance became a shop and the main building a furniture store. In recent years development of the site has an Italian restaurant on the main road and flats replacing the auditorium.

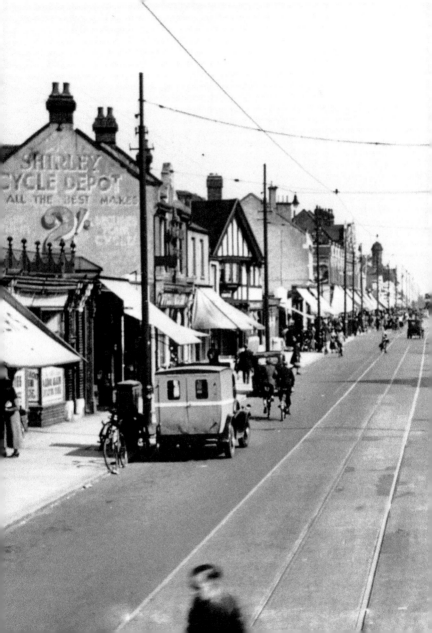

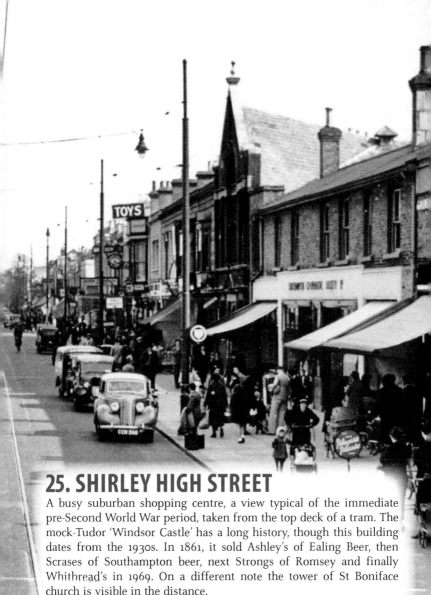

25. SHIRLEY HIGH STREET

A busy suburban shopping centre, a view typical of the immediate pre-Second World War period, taken from the top deck of a tram. The mock-Tudor 'Windsor Castle' has a long history, though this building dates from the 1930s. In 1861, it sold Ashley's of Ealing Beer, then Scrases of Southampton beer, next Strongs of Romsey and finally Whithread's in 1969. On a different note the tower of St Boniface church is visible in the distance.

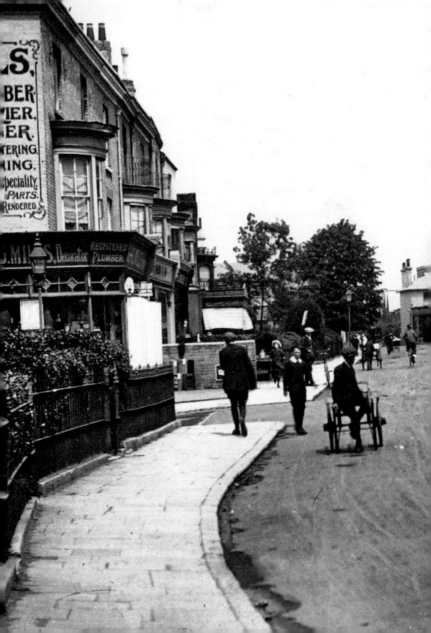

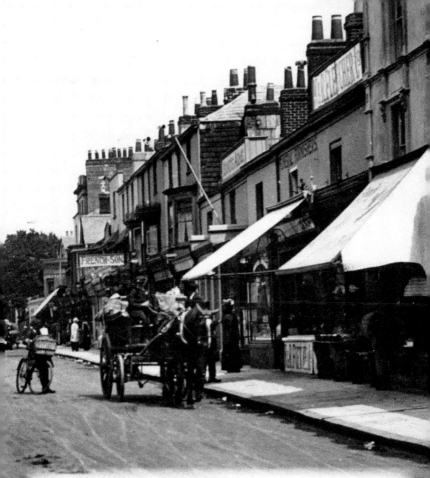

26. BEDFORD PLACE

Bedford Place remains as a shopping centre retaining virtually all of its period buildings with their many attractive features, including the shoe manufacturer and repairer shop of French & Son, which still serves its bespoke cliental. The only change is the white house in the distance removed to straighten up the road, replaced by St Anne's College, though there is still a kink in the road to mark the spot.

27. THE AVENUE

The John Ransom fountain donated to the town by Councillor John Ransome (1779–1886), a local business man. Inaugurated in 1865, it was moved northwards to facilitate road works in 1966. Note in the original the horse trough servicing a pony and trap. This part of the tree-lined avenue is now part of a one-way traffic system around the park.

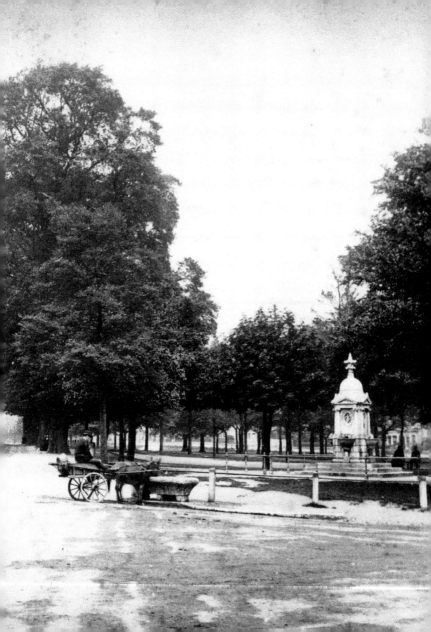

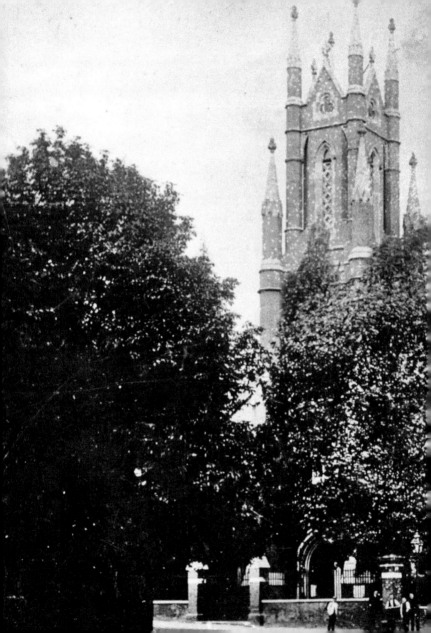

28. CHARLOTTE PLACE

St Andrew's Presbyterian church, built 1852/53, latterly a United Presbyterian and Congregational church, with its two rows of four pinnacles on the tower, was originally in a quiet backwater. However, it became redundant and was demolished in 1998 to be replaced by an office block. This is now the main road north from the town centre and a junction with the inner ring road is made with a large roundabout on the right containing a hotel and flats on the inside.

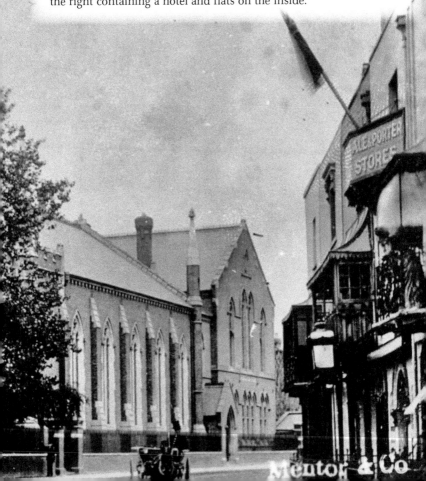

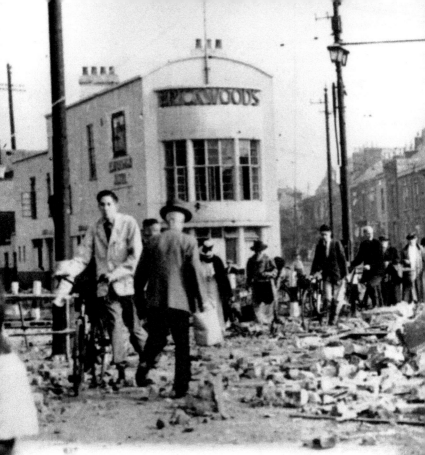

29. ST MARY'S STREET

The morning after bomb damage at Six Dials with people picking their way through the rubble to get to their work place – if, indeed, that had survived. Note the bridge, which is over the main railway line probably blocked by rubble from nearby houses. Most of the buildings in the original have been removed to allow for a multi-lane road junction, the other side of the trees bypassing a stretch of Northam Road.

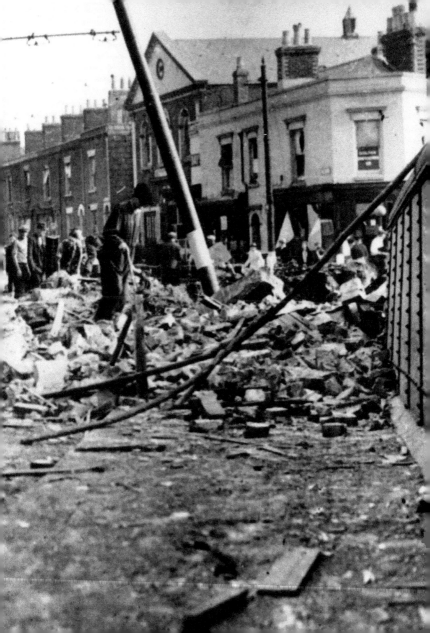

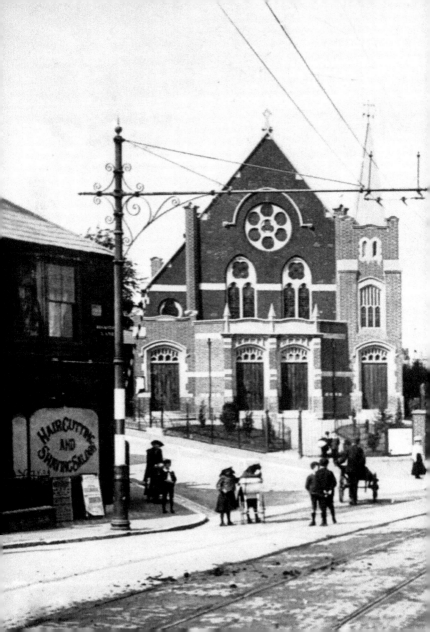

30. ONSLOW ROAD

A busy animated scene on a summer afternoon (the sun always shone in those days) with prominence given to the Bevois Town Methodist chapel. In the modern view the shops on the right are now a car sales lot, and there are changes in the distance on the left. The barber's shop has reverted to a private dwelling, but most of all the chapel, having been made redundant, is now a Sikh Temple (Gurdwara Nanaksar) with suitable modifications.

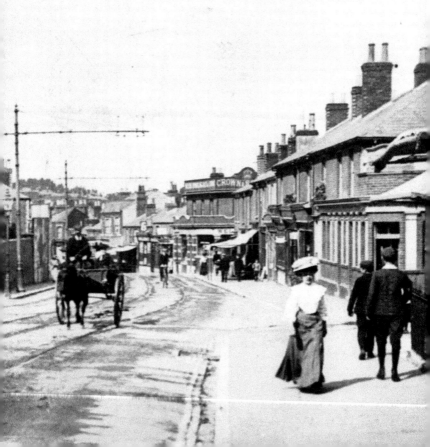

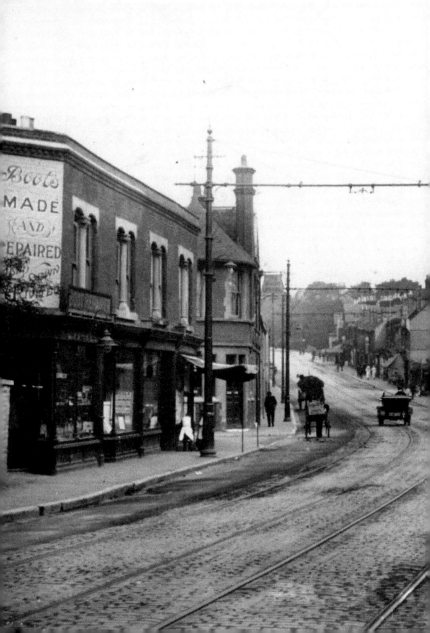

31. BEVOIS VALLEY

A little further down the valley you can no longer get your boots made or repaired, neither can you have a drink at the Mount Hotel, which closed in 1958. Once owned by Coopers Brewery, it was a Watney's house at the end. Some buildings are recognisable on the right, but one wonders for how much longer.

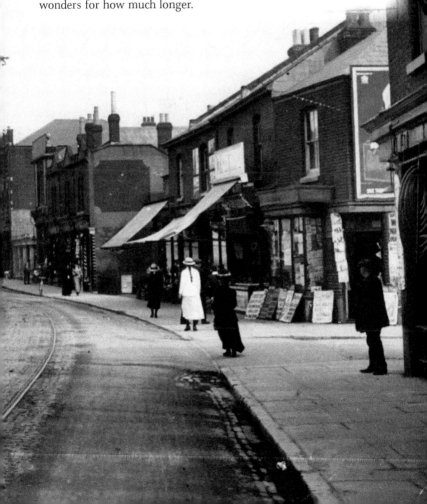

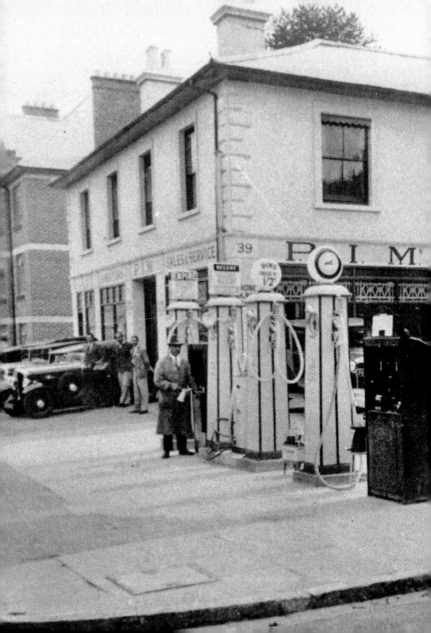

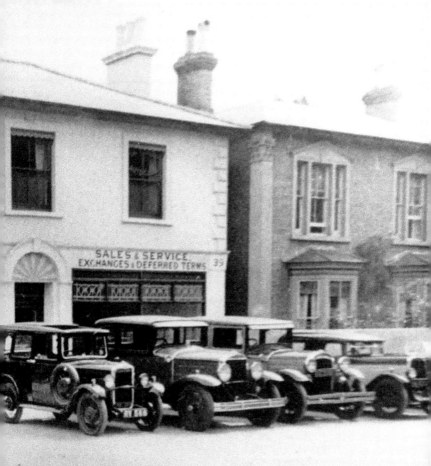

SALES & SERVICE
EXCHANGES & DEFERRED TERMS 35

32. LODGE ROAD

The corner of Lodge Road and the Inner Avenue at a location known as Stag Gates, the garage was trading as PIM (Portswood Incorporated Motors). Damaged during the war, it reopened as the Stag Gates service station but is now Avenue Cars, concentrating on sales and rentals.

33. PORTSWOOD ROAD

The Corporation Tramway Works where for some thirty-five years Southampton trams were built and repaired, followed in due course by maintenance of the bus fleet. However, rearrangement of the St Denys Road junction meant demolition with new buildings further back on the site and the area seen being used for open-air parking. All this is due to change, the bus depot having been sold to allow for a proposed supermarket, housing, and a health centre to be built.

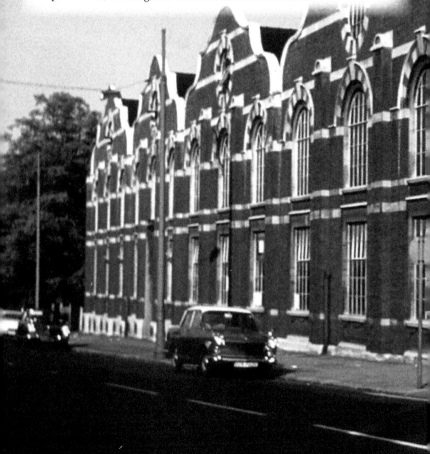

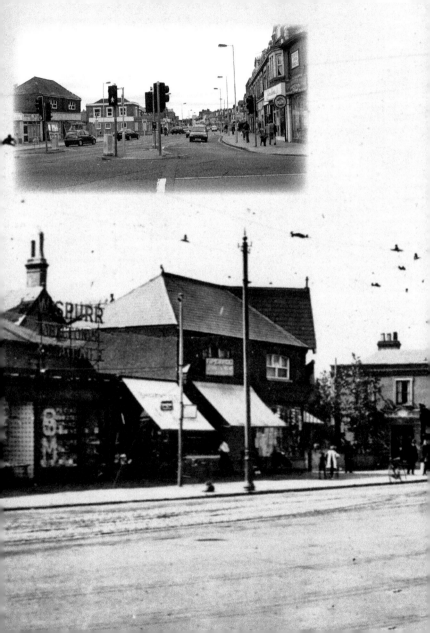

34. PORTSWOOD ROAD

Portswood (Tram) Junction, looking in this view surprisingly rural with unmade up roads. Two trams are in view, both with square-covered tops of the type that could not go through the Bargate, so they must be on the service to the docks via St Mary's. Otherwise all the buildings seen are still there.

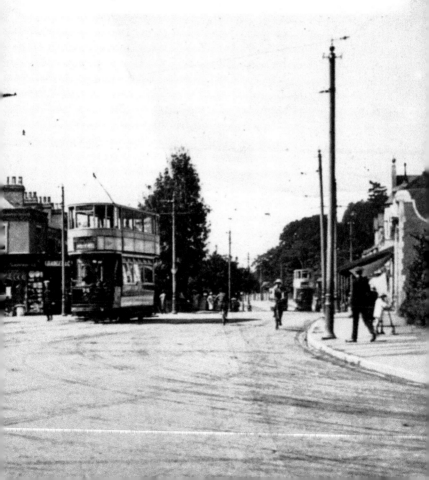

35. UNIVERSITY ROAD

The Hartley College situated in the High Street was short of space and decided to transfer to a green field site at Highfield. By the outbreak of the Second World War, building had progressed to this stage, leaving the central library block to be completed in the 1920s. The buildings, as shown with the addition of many temporary huts, became a hospital for the duration of the First World War.

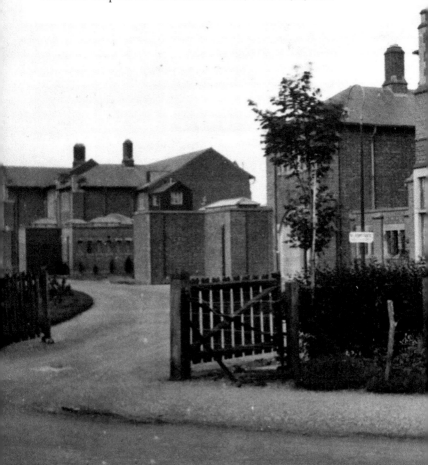

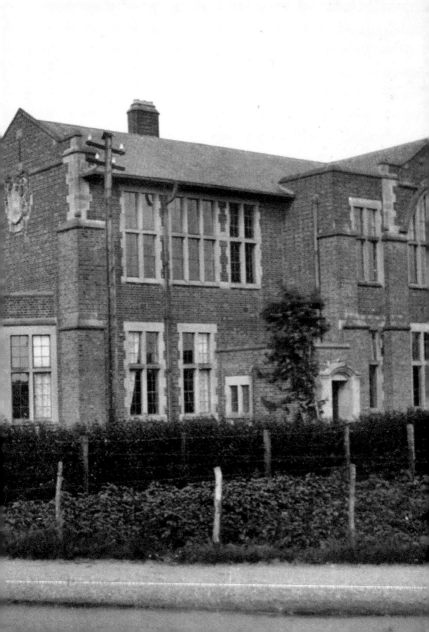

36. BURGESS ROAD

Known as Burgess Street until the 1920s, the turning on the left is now University Road, this side has succumbed to university expansion over recent years, though the right is comparatively untouched. As part of only two cross town routes north of the city centre, this idyllic scene is lost forever.

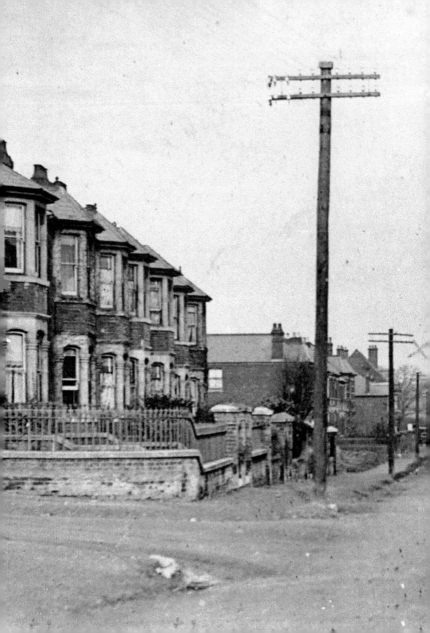

37. SWAYTHLING HIGH ROAD

Looking north from the other end of Langhorn Road, the left-hand side remains much the same, but on the right the club buildings have migrated from the other side of Woodmill Lane and the trees mark the position of the Savoy cinema (1938–1959), which originally had 1,505 seats, later was reduced to 1,032. Note the line of telephone poles, now replaced by streetlights and telephone distribution poles.

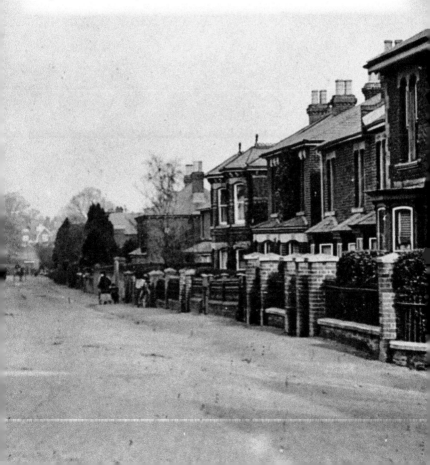

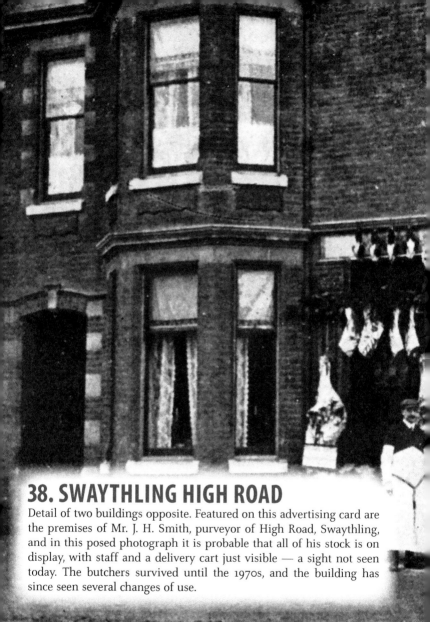

38. SWAYTHLING HIGH ROAD

Detail of two buildings opposite. Featured on this advertising card are the premises of Mr. J. H. Smith, purveyor of High Road, Swaythling, and in this posed photograph it is probable that all of his stock is on display, with staff and a delivery cart just visible — a sight not seen today. The butchers survived until the 1970s, and the building has since seen several changes of use.

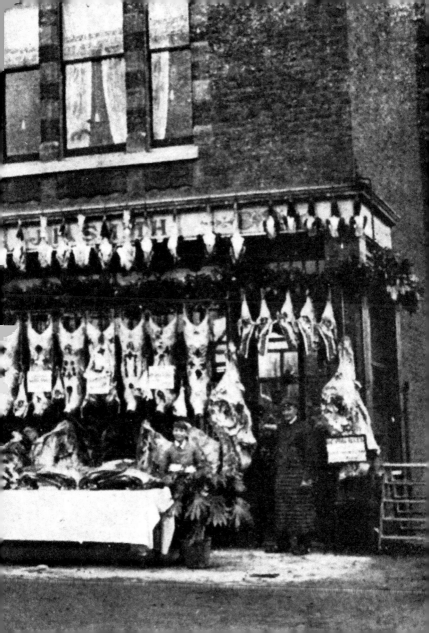

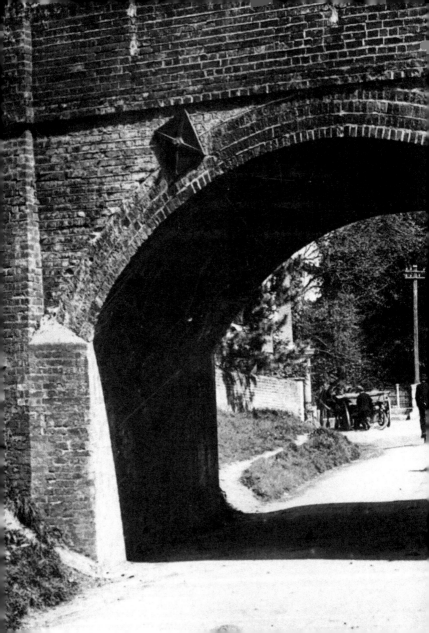

39. STONEHAM WAY

The notorious Swaythling Railway Arch, once a peaceful scene with the Fleming Arms just visible on the left and the bridge over Monk's Brook. This bridge has been responsible for the conversion of several double-decker buses into single-deckers and also lorries losing their cargo, and it is to be hoped that the warning signage will prove effective in the future.

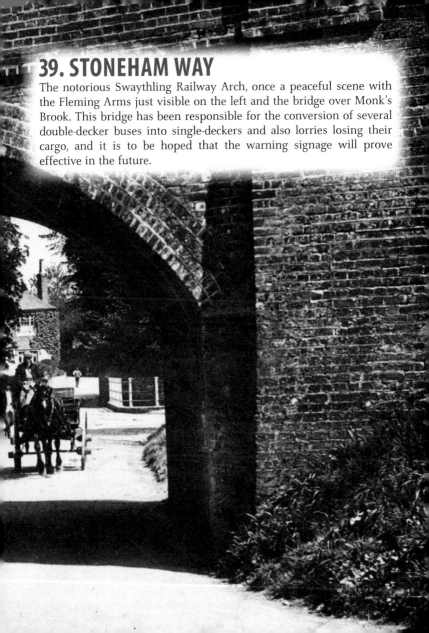

40. MANSBRIDGE ROAD

The White Swan (originally Middleton Arms *c.* 1810, then Swan Inn 1830, finally White Swan 1870) with the A27 main road. Note the bridge over the River Itchen that led to its Riverside Gardens. In the 1960s, it began to serve ploughmen's lunches and the buildings were extended. However, when the A27 was relocated some 100 yards south in 1970 trade declined, but refurbishment in 1988, which stressed the restaurant side, restored its popularity and, though occasionally being flooded, it maintains its popularity.

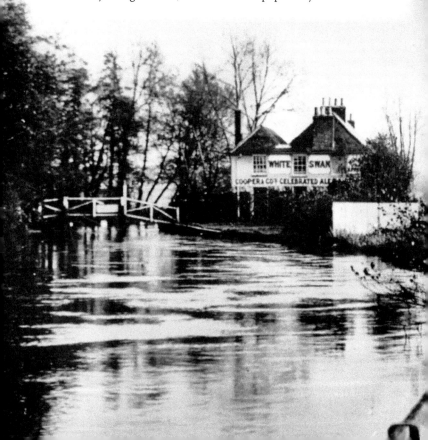

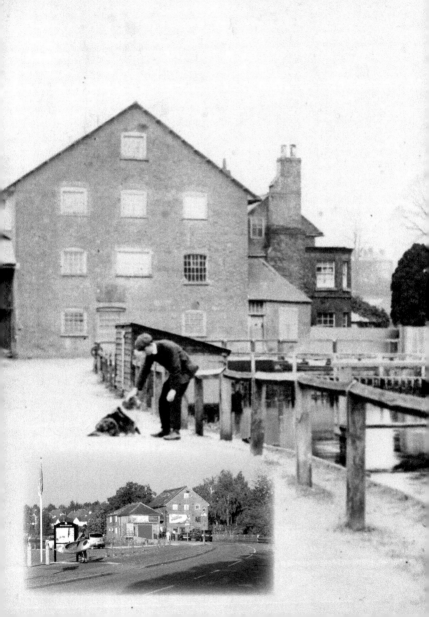

41. WOODMILL LANE

There has been a mill on this site for centuries, though this building only dates from 1820, the previous structure having burnt down. This mill, however, has gone down in history as being the factory that manufactured the wood blocks and pumps for the ships of Nelson's Navy from 1780 until 1810, by when the navy had built their own facilities at Portsmouth dockyard. Every morning seagulls take residence — usually as ridge decoration, but if it gets too crowded then any old bit of roof will do.

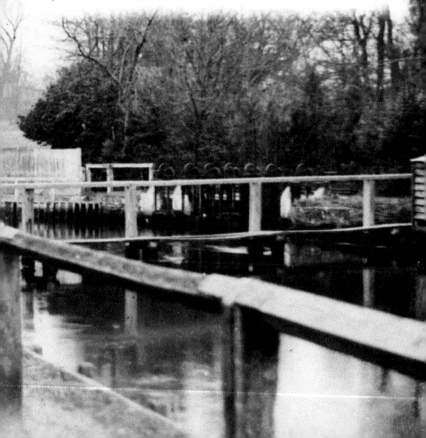

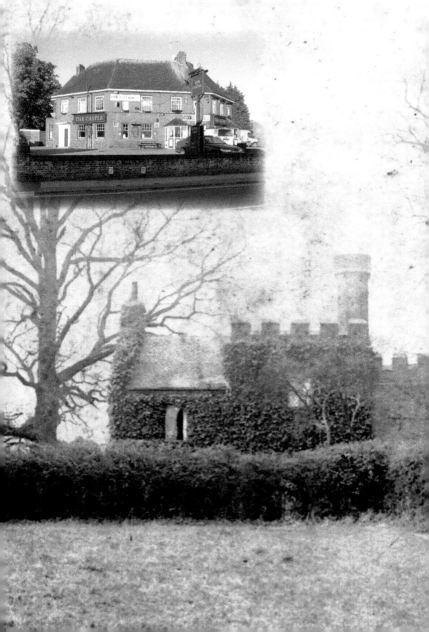

42. WITTS HILL

Midanbury Castle, so called for obvious reasons, was actually the gatehouse for Midanbury House some way to the rear. The estate was purchased in 1927 for development by the builder T. Clark & Son and the house was demolished soon after, but the gatehouse survived into the mid-1930s, being replaced by the pub before the Second World War. It is still open after some problems and, remarkably, has not been inflicted with a fancy name change.

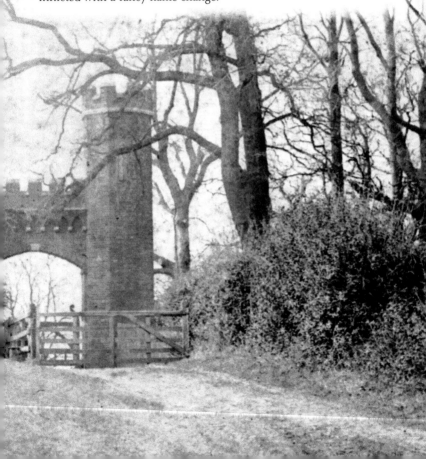

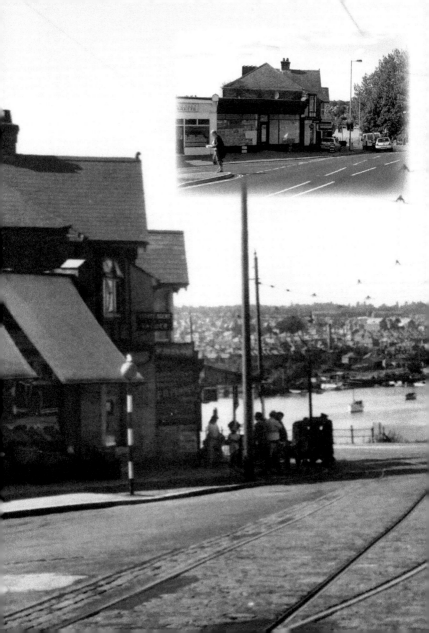

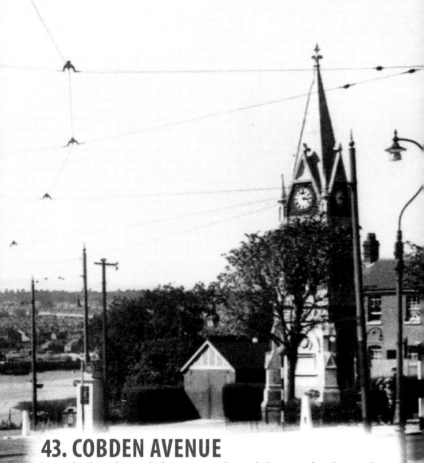

43. COBDEN AVENUE

Not a lot has changed, the tram tracks and their overhead wires have gone, and the trees have grown, obstructing one's view of the river Itchen. Prominent on the right is the clock tower, which migrated from New Road/Above Bar in 1935, and it originally had a drinking trough for horses and dogs on the north and south sides with a drinking fountain for the two-legged on the west. I think this tower is leaning to the west, which can just be discerned in the photograph (Southampton's Past).

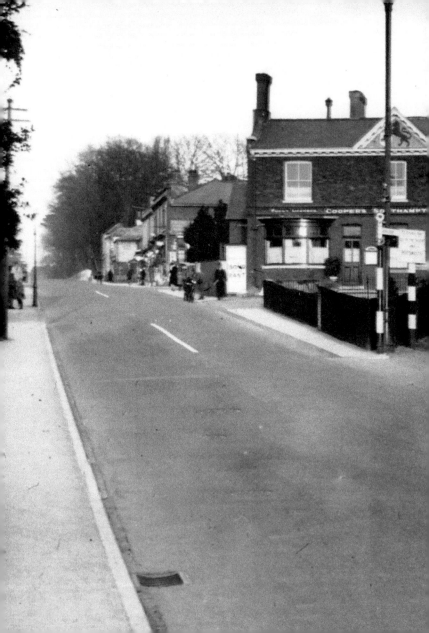

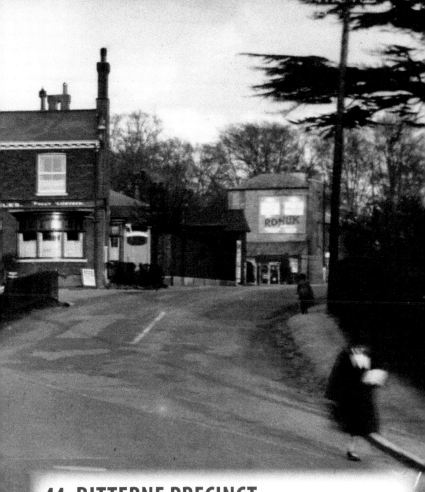

44. BITTERNE PRECINCT

The Red Lion, which replaced an earlier building in 1860, though with some later alterations, stands at the junction of the main roads to West End and Burlsedon, which in later years became something of a bottleneck, so it was with relief all round that traffic was diverted to the north and the road through Bitterne shopping centre pedestrianised.

45. NORTHAM BRIDGE

One of those 'smile please for the camera' photographs so common in early views, but they still convey so much atmosphere, the young looking lad with pony and two wheeled cart – is that milk he has? – and the horse and cart making its way through flooded foreshore. The timber ponds and the iron bridge can be seen in the background.

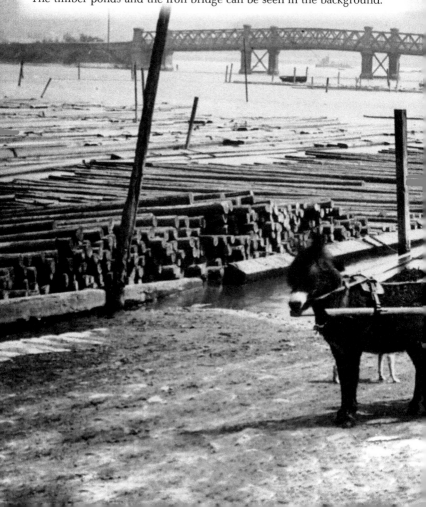

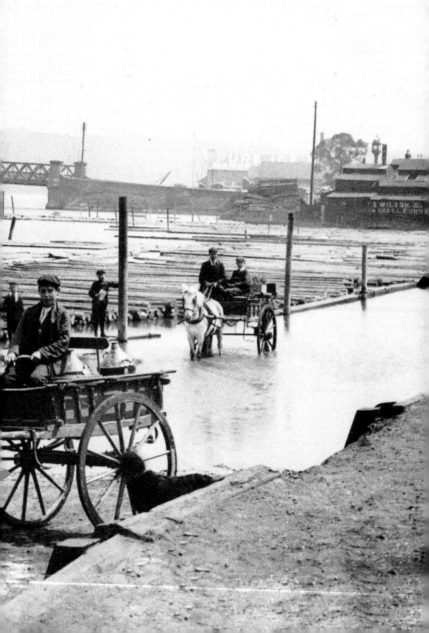

46. MARINE PARADE

With the advent of North Sea gas, all gasworks became redundant and, even though it had converted from coal to using by-products sourced from Fawley refinery, Southampton was no exception. The bridge had been used to bring coal from wharfs on the Itchen to the works. When Southampton Football Club, then in the Premier League, were looking for a larger stadium they were forced to use this 'brown field' site rather than their preferred location on the edge of town.

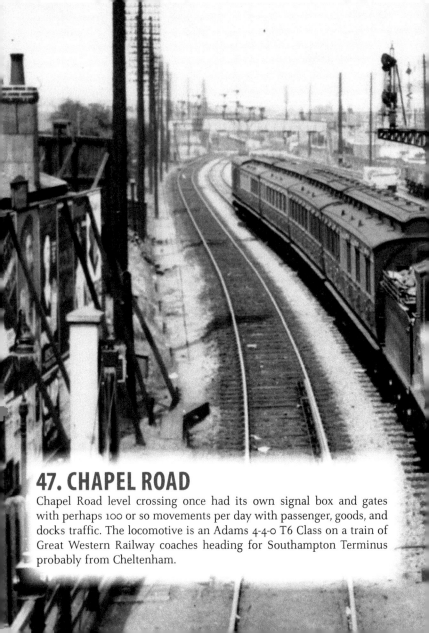

47. CHAPEL ROAD

Chapel Road level crossing once had its own signal box and gates with perhaps 100 or so movements per day with passenger, goods, and docks traffic. The locomotive is an Adams 4-4-0 T6 Class on a train of Great Western Railway coaches heading for Southampton Terminus probably from Cheltenham.

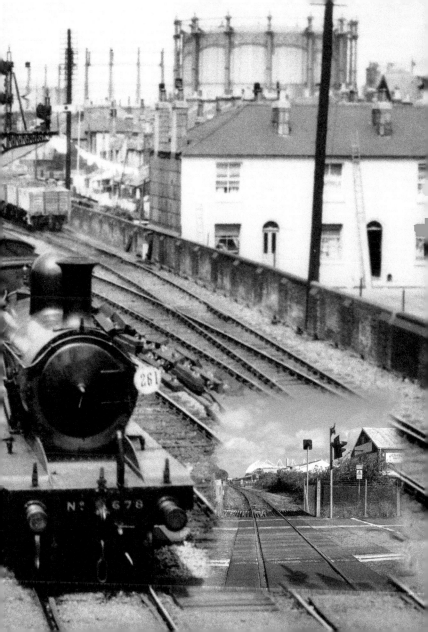

ACKNOWLEDGEMENTS

I have endeavoured to group the illustrations on areas of the town albeit on a somewhat random basis with the general idea of showing what a difference the motorcar has made to the roads many of us use every day.

The 'then' pictures are all in my collection mainly, old postcards some 100 years old. However, there are two photographs that I must credit: page 5 to Tony Chilcott and page 65 to the National Archives, Swindon. I apologise if any other credits have been omitted.

Also I must thank Mary, my wife, for doing the typing, carrying the camera bag and putting up with the chaos at home I have caused during preparation of this book.